A Proper Hedgehog
Vintage Christmas Annual

First published 2024 by The Hedgehog Poetry Press

Published in the UK by
The Hedgehog Poetry Press
Coppack House, 5
Churchill Avenue
Clevedon
BS21 6QW

www.hedgehogpress.co.uk

9 8 7 6 5 4 3 2 1

A CIP Catalogue record for this book is available from the British Library.

ISBN: 978-1-916830-44-8

Contents

TOBOGGANING.

AQUARELLE PRINT BY L. PRANG & CO.

MANDY WILLIS

Twelfth night

My mind wanders as I remove pins, roll lights, carefully wrapping our treasures.
Echoes of Christmas' past time travel through tinsel and glass.

I recall the red gold theme of our rent friendly trees.
Battered and fraying now but still capturing our early couple dreams.
The wooden calendars gifted by grandparents when the children arrived.
The one legged donkey; Santa still holding his intricate parcels up high.

Nonchalant teens now laugh at baubles and felts they had lovingly made.
But I placed them proudly, as beside the more tasteful they are never upstaged.

Each year as we hang them, usually later than planned.
It's our family history evolving in the palm of my hand.
Their time with us fleeting, only one month in our year.
A testament though that whatever happens in the other eleven, we all will endure.

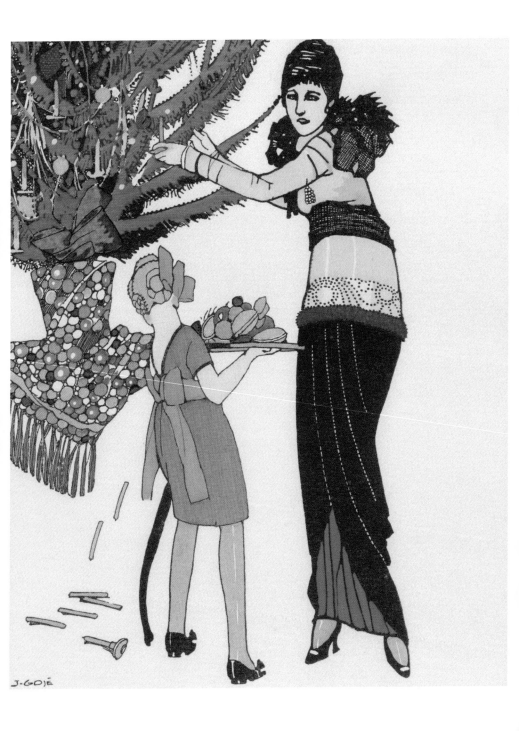

GILL HORITZ

A longed-for Christmas tree

What comes back, desire
for what was never there,
a feeling now of something
not easily spoken about,
a longing for what might have been,
mother and father carrying the weight
into the house of a forest tree,
utterly green, limbs
outspread in the living room,
for a moment
something to speak about
as we lean in, a gathering
of the trees making.

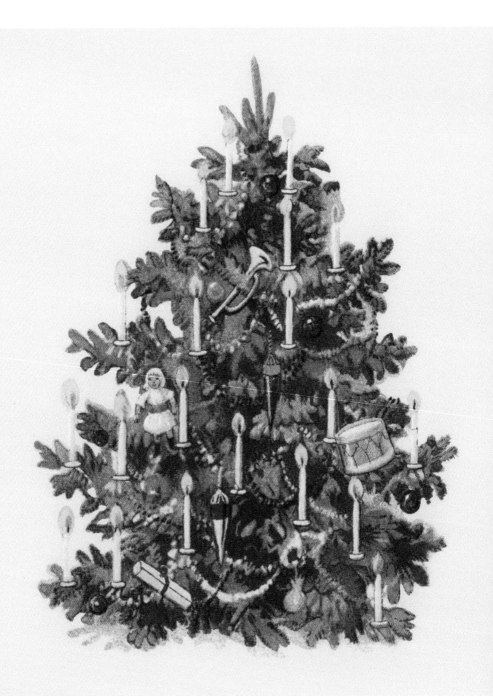

MIRIAM OTTO

I Still Believe in Wishes

I believe that Santa lives in the North.
4 reindeer and snow. All year long.
I don't know what he is doing in summer.
But what I know is that I learned
a lot about my wishes.

My grand-mothers encouraged me.
So I wrote my own letters before
I was six. Until it became a habit
before Christmas.

I still believe that some dreams come true
and others do not. I learned to be precise,
to cut my future out with scissors,
glue it on paper. And that it is important
to send my letters out.

PHILIPPA HATTON-LEPINE

the six decades of christmas

1977
this day is all about me - presents under the tree, rich food, sugar rush
by evening it is almost too much, yet not enough
to last the coming year
leave them wanting more my grandmother says
still, she puts another toffee in my mouth
to sweeten any tears

1980
after I realise that Santa is in fact Mr Cooper
sit awkwardly upon his knee anyway
I sneak into my parents room to find my gifts before the big day
then feign surprise - play their game
try to smile the guilt away

1999
in the week before we are due to catch the millennium bug
we share our last christmas with my mother
it is probably warm, bright, full of laughter, fights
I don't remember a single minute of it
I know the world doesn't end in 2000
I also know that it does

2000
a pause in the middle of a long sentence
contemplating, waiting for children
we have not yet met
to give us reason for the gifts we give
the food we eat
the bright decorations

2012
I forget the batteries
for my son's new car
and when he is sick after too many sweets
his great grandmother gives him *just one more*
to settle his stomach apparently
best day ever he says to me

2020
christmas fear-
masks, hand wash, travel tiers
don't send cards!
don't spread more than festive cheer!
memories, hope for next year spent with lovers
friends, family
this day was never all about me

KATRINA MOINET

Do They Know

Every time you go away, you take
Another little piece of my Mull o' Kintyre

Like mistletoe and wine
You were always on my mind

Oh, I wish it could be Christmas
Every day, I wanna hold your hand

Then I go and say somethin' stupid, like
Don't you want me, baby?

Stay another day. We can work it out
I have a dream, I will always love you

We built this city, but
2 become... Too much

Can we fix it?
When we collide

I'm just another brick
In your bohemian rhapsody

When you believe
Killing in the name of

Saviour's day
Save your love

Wherever you are
You'll be lonely this Christmas

Hallelujah.

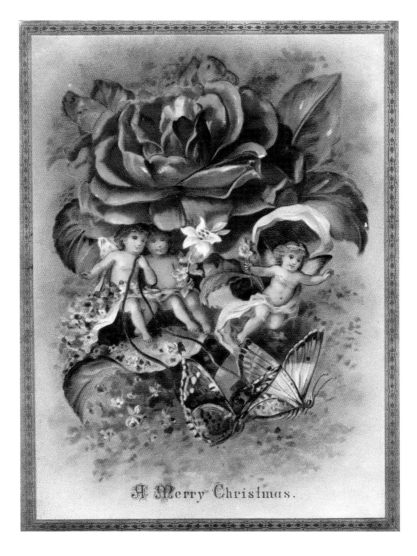

A Merry Christmas.

includes Christmas #1 song titles from: The Beatles (1963 & '65), Queen ('75), Wings ('77), Pink Floyd ('79), Human League ('81), Renée and Renato ('82), Pet Shop Boys ('87), Cliff Richard ('88 & '90), Band Aid (1989 & 2020), Whitney Houston ('92), East 17 ('94), Spice Girls ('96 & '97), Westlife ('99), Bob the Builder (2000), Nicole Kidman & Robbie Williams (2001), Leon Jackson (2007), Alexandra Burke (2008) Rage Against the Machine (2009), Matt Cardle (2010), Miltary Wives (2011), Ladbaby (2018)

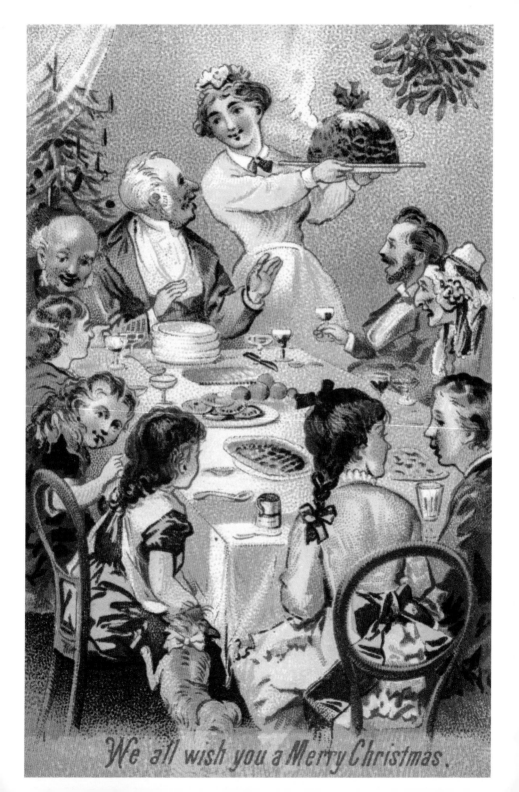

We all wish you a Merry Christmas.

MARGARET ROYALL

Yan, tan, tethera

A Cumbrian Shepherd Counts Sheep

Hoar-frost layers its tracery on forests, fields and fells;
the shepherd hugs his wool cloak tight to his stiff limbs.

Close-purled like stitches on a fresh-knit ganzie
his Herdwicks bleat retreat in the village pinfold.

.
He counts the flock, beast by beast, pats each head,
tallies the score, notches his crook...... yan, tan, tethera;

their silhouettes silvered by the glimmer of first stars,
they ruminate, as he shuts the gate, fades away like a winter ghost,

disappearing into the cosy womb of the Nag's Head,
hanging his cloak on the nail, eager to join the festive revelry...

From a nearby lonning midnight bells call to worship...

He is so very far from Bethlehem on this bone-bleak Cumbrian night.

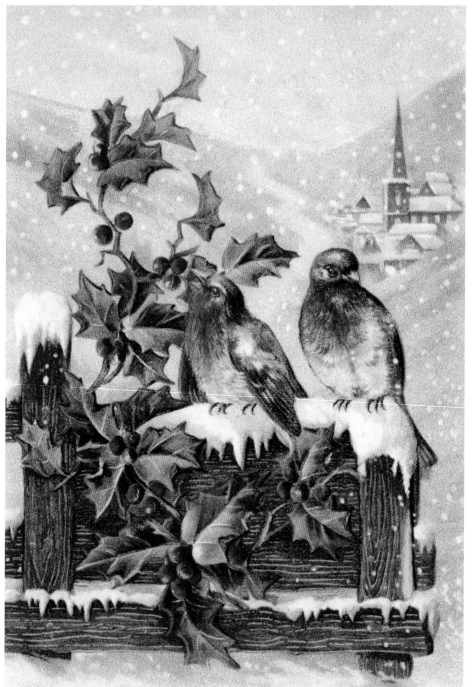

A Merry Christmas.

PAUL SHORT

Decorating the Tree

We chime the bell
a golden memory of Copenhagen
crowning the tree for this year

draping ourselves on the sofa
we toast December's beginning
while Tim Minchin plays *"White Wine in The Sun"*
our lips mouthing every word
between the fading in and out of silver fairy lights

our boy nestles between us
paws up and head resting on your knee
we share a smile
lips snow-tipped with cocoa and cream

it's the feeling of cosiness
when it's just us
that I wrap myself up in
like a well-worn Christmas jumper
ready for the festivities to come.

RICHARD HOUGH

The Family Christmas

Peace on Earth,
an early night.
The Virgin Birth,
kids who fight.
Up at dawn,
open the gifts,
a tin horn,
snow that drifts.
Fools and Horses,
Morecambe and Wise,
too many courses,
hot mince pies,
fresh brandy sauce -
the King's Speech,
chocolates of course;
a quiet beach.
Cold turkey tea,
fun and games,
some more TV,
calling of names.
Alone at nine,
kids in bed,
some more wine,
a sore head.

Christmas – 1904

PHIL SANTUS

Forgiveness at Christmas

You have come here this Christmas,
like a ghost from a half-forgotten dream.
Have you thought about Jesus,
in this celebration of love and birth?
Does he mean something to you?

Will your regrets reform you?
You left us when we needed you the most
but somehow, we survived it,
though the kids couldn't help but blame themselves.
Please consider such damage.

Can we trust you once again?
We will take solace from your contriteness,
and give you a chance, perhaps.
So come on in, and a Merry Christmas,
we'll find a way to forgive.

WENDY GOULSTONE

The day I ate all the chocolates on the Christmas tree

Let me clarify this for the records.
I have no personal knowledge
of having committed this crime
only the words of my mother
repeated
every successive Christmas day
an accusation which I was not
in a position to deny
nor for which I would apologise
except to smile weakly and hope
that she would not then mention
that other Christmas when
supposedly
I tipped all the pieces
of my sister's new jigsaws
into a great pile on the front room floor.
 I prefer to remember myself
as a sweet little girl dribbling happily
into her bib
which I am sure I was.

L'ARBRE MERVEILLEUX

Costumes d'enfants pour Noël

JAMES ALEXANDER

Christmas is . . .

(delete as appropriate)

coming
carnage, chaos
kindness, cruelty
crimson, cranberries
Christingle, carols
cold, costly
critical, Covid
cancelled.

PHILIPPA RAMSDEN

Dreaming of a White Christmas

December days shuffle on
 excited chatter,
 snatches of carols,
floating
 muffled
by a downy coverlet
 woven from
single snowflakes,
 falling, falling
softly landing
 with an
 almost
 perceptible
 crunch
as they layer
and
huddle together
 on the first
 surface
 they meet.

Weaving together
 hopes, dreams.

Whispering promises
of a perfect Christmas.

NISHA PEARSON

Christmas Cheer

What Christmas means to me.
Hanging decorations on the tree-
Filled with laughter and fun for everyone-
Music echo's from the bandstand,
Cherubs however small-
Bright and rosy cheeks they call.
Looking at Santa's throne,
Height of the season reindeers roam.
Bright lights glisten.
From dusk till dawn.
Snowflakes Hover,
On the rooftops.
Hands wrapped around coffee-
Filled with sugar and spice.
'And all things nice'

Handing out presents,
To put beneath our alters-
To share with our sons and daughters,
The church bells ring out from afar.
Looking up we see a bright star.
Reminds us of our lord Jesus Christ.
Who gave for us-so that we had life.
Oh, what Joy they bring.
Leaping lords, good will to all men.
We are spent by half past ten.
Kids asleep wrapped up and warm.
Christmas cheer is soon forlorn.
Sleepy eyes drifting now.
Lost in faraway lands.
As dreams draw in-
And real life begins.
Bringing back yule tide.

ISABEL MILES

Solstice Sonnet

For weeks the sun has shrunk, warmth waned.
Earth's pendulum has swung its maximum.
This still point in the seasons' curve confronts
unravellings and absences, what's left undone.
Dim noon is powerless against deep-rooted frost.
On branches bare as bone, birds huddle,
colourless and slow as the reversion of the sun.
The world waits, hushed, as earth's tilt shifts.
Now is the Yule that was, before drunk revelling
and frenzied spending guzzled calm.
Unhurried feast of stillness, silent nights, and dawns
that rise a little earlier each day to kindle
candle-berries on the yew, flames bright enough
to light what's been, and what's to come.

PENRHYN STANLAWS.

WINTER.

JUNE WENTLAND

Christmas Wishes from the 1970s

Garlands up and silver tree
entwined in tinsel,

presents bought and wrapped
and mince-pies eaten,

unable to sleep, I crept
to the window, staring out to see

the winter geese flap across the fields
towards the distant glimmer of the *Ferry Inn* –

where Great Aunt Doris, encumbered by less
decorum than her sisters –

played darts, drank Guinness.
On again, the grey geese flew

across the snow, towards the river
and past the station

where someone had painted
on the wall a festive message

of hope, equality and freedom:
One Man One Vote Rhodesia.

CATHERINE HEIGHWAY

on the charity's website

a photograph of a little girl
huddled in a doorway
filthy t-shirt pulled over bent knees
thin arms wrapped around herself
small head turned to one side
I see her around every corner
as I push laden shopping cart
through the grocery store
while Judy Garland sings
Have Yourself a Merry Little Christmas

KATE YOUNG

Christmas, 2022

After 'Driving Home for Christmas', Chris Rea

End of term, post-bubble
thirty pairs of excited eyes
graze the Year One party
free to sing, dance and mingle.

Even the M25 is joyous.
A red ribbon of light
snakes the motorway.
The radio screams Christmas.

At Newport Pagnell
I skate among travellers
careful to keep my distance.
Negative space a new habit.

The house is ablaze with jazz
and sax, my son on keys
a Jackson Pollock abstract
splashed across the canvas.

We laugh, bicker, criticize
tongues tipsy with fizz or love,
my daughter like a whirligig
jigging round the kitchen.

Christmas Eve, tree lights
in the garden, wisps of cloud
caress the sky as we salute
the unmasking of the moon.

CHRISTMAS TREE.

KATE COPELAND

Christmas cards I will not send

Avoiding snow, not dashing, flying to
México we were, a Christmas together, over-the-top
Pooh-decorations in over-lightened
gardens, roundabouts filled with red-white-green.
Mariachi music, louder-loudest.

We laughed a lot, your irresistible wit, winter
didn't hurt like an edge, there,
candles burned up other meanings, falling water
un-fenced me, and you, we travelled pyramids,
to find our common ground.

Found. A gulf with whales, a bay to bury fish
in sizzling sand, edible after an hour. Love. Promises.

The next year, the extra days
I pushed again on holidays there
and you agreed, yet went night-diving alone,
weighed this tiny girl in white,
on boxing day.

I hit my head on a Cacao Tree,
I always ran back then, back home
where Whippet clouds, family-togethers and
abroad, from gifts you took. The immediate spouse.
Hotel walls too thin here.

It couldn't get any better than
falling apart, I am travelling solo to Buenos Aires today.

Packing is worse on grey days, hard to believe
in winter sun, to switch from coat to bikini.
You stay my season travel mate in memory, I understand
now, here, with me, Christmas
was not always a sugar-sweet gift I gave, my trust, my love.

A Merry Christmas and a Happy New Year.

HEATHER MOULSON

Christmas Special

Opening a brand new *Bunty* annual
Sitting at Mum's feet like a cocker spaniel
was a nine year old's Yuletide bliss.
And of which I constantly reminisce.

Festive bonhomie with beehived aunts
before consuming one too many advocaats.
It was Gran who usually threw the first punch
just after the splendid turkey lunch.

The Christmas spirit turned blue quickly
but I didn't care, I was reading the *Dandy*.
Sent up to bed before things got nasty
and various relatives got drunk and arsey.

Laying on Gran's bed in contentment,
I never heard the downstairs resentments.
Armed with R Whites, sweets and my 1970 *Mandy,*
Gran's drunken temper came in handy.

KELLY DAVIS

Christmas Cinquains

Our sons
woke before dawn,
ransacked their packed stockings,
ignored tangerines, gorged chocolate
gold coins.

The tree
dripped with tinsel,
baubles and coloured lights,
presents piled round its base, like a
snowdrift.

In a
moment, gifts were
unwrapped. Torn paper went
into black bin bags, along with
vital

leaflets
explaining how
to assemble complex
toys. Then into the kitchen to
peel spuds.

We cut
crosses into
Brussels sprouts, wrapped bacon
round chipolatas and checked the
roasties.

Seated
round the table
rather late, we carved the
bronzed turkey, passed the gravy and
parsnips.

We pulled
Christmas crackers,
groaned at the awful jokes,
the pungent smell of gunpowder
hanging

in the
air, along with
the realisation that
there was steamed Christmas pudding still
to come.

Then a
bracing walk on
the Sea Brows. Tea and cake
on our return. Attempts to build
those toys

without
instructions so
carelessly mislaid. Sons
now grumpy and starting to
squabble.

Later,
when our hunger
finally returned, cold
turkey sandwiches on buttered
brown bread.

Sitting
by the fire, we
drank whatever was left,
basked in sentiment – and staggered
to bed.

CARMELLA DE KEYSER

Shake the Christmas Globe!

When you shake the Christmas globe –
A festive scene appears!
Miniature figurines,
Proclaim that Christmas cheer is near...

You will see movie duvet days and cousin rivalries,
Trivial pursuit games and cards of golden glitter glue,
You may ride within a hushing dream,
On a silken sleigh at twilight,
Betwixt and between, the marvellous sheen, of a star littered stickered sky!

In merry, dressed up, bow-tie houses – are ornaments of red, gold and green,
And Santa's plate of tangerines waits, under the evergreen tree!
There may be snuggling, hugs and snowy cold weather,
And plump, good-natured, characterful snowmen,
And tables pursed with cinnamon spice, and chocolate fondue fountains!

Between your palms, you entirely hold the key to a magical old snow globe!
And it contains a joyful, bold, emotional, tender world,
Of memory melodies, quick-stepping and turning-
In hearty homes where family tales are told.
And if you peek around, in the still of the globe's night...
Its sky is blinking, with twinkly, frosting fairy lights!

Now hush and shhh... lets shake together - for just one more cushy sleep...
And the snowflakes may gently, waltz and cleave,
Into the alchemy, of a cosy Christmas Eve,
Where baby fingers, knead pressies and curiously plead,
To see, which promises are resting and sleeping beneath,
And atop a crown of thorns and berries,
Two turtle doves sing of resurrection stories,
Heralding the beautiful dream of the white crib and the tree!

Tis the season to cease all worries,
And give one's whole essence,
Towards others happiness!

And shaken in between -
Are inter-generational smiles, fuzzy hearts closely beating,
Fulfilment, humble gratitude, respect at how time is fleeting,
There are carols, candy canes and gingerbread men...
But most of all the chance to be a little dreaming child again!

"Remember, if Christmas isn't found in your heart, you won't find it under a tree." - Charlotte Carpenter.

LIZ KENDALL

That'll do

After an '80s childhood of neon sweets,
candy cigarettes, rollerskating 'til dusk
and tinsel on everything at Christmas,
there is a paring back.

I work. I cannot face the hours it takes
to make an amputated tree stand steady;
persuade it not to shed hairs like the dog
that died when I was in my teens.
Positioning the lights, winding to conceal
the bare patch of bulbs that no longer light up.
I know how they feel.
My spark, too, is inconsistent, wearing thin.
I cannot do it all. I can't keep all bright.
I never was the life and soul, not even in my youth.

Pulling on boots, trudging down the garden;
all wild but wilder at the end; breathing damp chill.
The foxes under the shed, wondering what I'm up to.
I see their conduit through the beech hedge,
the patch of light they slink through,
merging into their own shadows, borderless.

Holly has legged it and flung its tendrils out,
reaching like an octopus; the tight spikes
and green gloss looking so tidy,
ignoring the tangled mess they grace.
There is a tree somewhere inside it;
the leaves bespeak its dignity.

Inside the house is a vase for tall lilies,
elegant. Its narrow throat
will sing these straggling prickling ends
into the harmony of carols sung in church.
They flower out, and the small baubles and bows
sit convincingly enough. Glimmering.

Remember Mary, how she made do.
Remember Joseph; we can't all plan ahead.
In the end, hospitality is opening the door
whatever kind of door it is;
don't fret about the thickness of the wood.

LIZZIE BALLAGHER

Seven Candles

Light me a candle for sorrow:
for the one on a journey with no returning
and pennies on his eyes for the burying.

Light me a candle for tomorrow:
for the tug of longing & the loss of hope,
for the winds of war & the stuttering of prayer.

Light me a candle for blissful memories
in the darkest hours of night:
for sunlit colours & the laughter of friends.

Light me a candle for thankfulness:
for the holy moments of marrying,
for childbirth & the first faltering prayers of children.

Light me a candle for blessedness:
for bread & wine on a sacred table—
to stand & burn in beauty & in tenderness.

Light me a candle for gladness:
for a welcome at windows late in the evening,
for the hush & stillness of soft sleep.

Light me a candle for peace:
for the swansdown drift of dreams;
for the gift of Christ at Christmas,
and for His rising on Easter's radiant morning.
Yes, light me a candle for the breath of day's dawning.

The hiss of a flame, the flare of a spark
will raise us soon against the dark.

OZ HARDWICK

Christmas in a Forgotten War

It's a short winter walk from sublime to ridiculous, from carolling choirs to a dog in a Santa suit, but all the world's frozen into stillness and the same frost shines on church bells and car bonnets. Over the door, a crow taps the feeder with its love-hungry beak, while the cat regards it like a connoisseur through the porch glass. The fire's crackling for the first time this year and we're quoting the same old movies, word for word, with all the accents and inflections. There's neither peace nor prosperity, but the house is plump with roasting vegetables and dimmed lights. We'll write our names in pine needles, predict modest futures in tealeaves, and wait for the phone to startle the cat from his daydreams. Friend or foe? It could be anyone, but today we'll welcome their voices.

I USED TO WANDER O'ER THE EARTH
 WITH TROPHIES FOR YOUR STOCKING.
OF TRANSPORTATION THERE WAS DEARTH
 AND LIGHT AND HEAT WERE SHOCKING.
I FELL AND FUMBLED IN THE DARK
 AND GRAZED MY SHINS AGAINST THE BARK;
BUT RUMBLED ON TOWARDS THE MARK,
 WITH CHRISTMAS PRESENTS ROCKING.

B UT NOW, LOOK AT MY SMILING FACE;
 NOTE WHAT MY DARING NERVE IS.
IN EASE I FLY FROM PLACE TO PLACE
 AT SPEED THAT SHOWS WHAT VERVE IS!
MY FLEETING DEER ARE GONE, ALAS!
 BUT ALL THE HOUSES THAT I PASS
ARE 'LECTRIC LIGHTED-OR BY GAS
 FROM OUR "PACIFIC SERVICE"

TINA MACNAUGHTON

Pine Tree on the Square

The pine tree stood quite plainly on the square
No lights, no decorations, star nor angel there

A thin pale waif lay resting on the street
She looked so cold, had nothing on her feet

A man walked by and had a little chat
Her blue eyes smiled, she talked a little back

A lady brought a nice hot chocolate drink
That kindness made others pause and have a think

A sandwich, blanket, shoes, gifts placed with care
The poor waif beamed as people came to share

The square emptied, quietened, day settled into night
The next morning the girl had gone, nowhere in sight

But suddenly the square began to glow
The pine tree blazed with light, it twinkled so

And at the top an angel, eyes so blue
Just needed love, she said, *and I thank you.*

ALLEEN. IWAN. HAD.GEEN.PLEZIER.....

C.GOES.

CEINWEN E CARIAD HAYDON

Memories, Welcomes and Celebrations

Each year, around the festive table
there are yawning gaps, as well as fresh
new faces to welcome. We remember
and yearn and hug and include, we make
fresh memories to feed and sustain us.
I understand the cast is unique to each
specific Christmas Day, and yet –
hands, present and absent, squeeze
everyone's shoulders with tenderness
as separations fall away
and what we share, what we have shared, remains
at the living core of our celebrations.